APERTURE MASTERS OF PHOTOGRAPHY

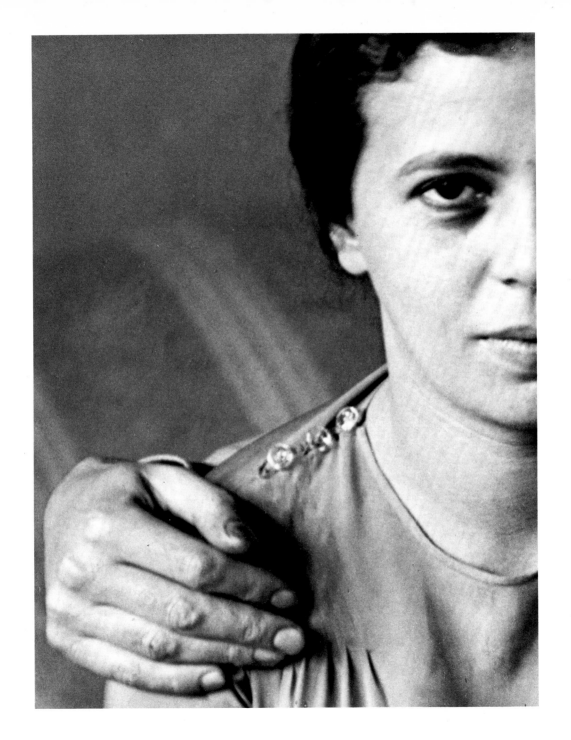

ANDRÉ KERTÉSZ

With an Essay by Carole Kismaric

APERTURE MASTERS OF PHOTOGRAPHY

NUMBER ELEVEN

The Masters of Photography series is published by Aperture.
André Kertész is the eleventh book in the series.

Copyright © 1993 Aperture Foundation, Inc. Text © 1977,
1993 Carole Kismaric. All rights reserved under International
and Pan-American Copyright Conventions.

No part of this book may be reproduced without written
permission from the publisher.

Manufactured in Hong Kong.

Series design by Alan Richardson.

Library of Congress Catalog Number: 93-71075

ISBN: 0-89381-362-1 (cloth edition)

ISBN: 0-89381-363-X (paperback edition)

Aperture Foundation publishes a periodical, books, and
portfolios of fine photography to communicate with serious
photographers and creative people everywhere. A complete
catalog is available upon request.
Address: 20 East 23rd Street, New York, New York 10010.

André Kertész's pictures are deceptively simple. They are devoid of extravagance, of excess, and of artificiality. And astonishingly they have been so from the very beginning. Through more than sixty years Kertész has worked without pretense, in self-observation, using the camera to question, to record, and to preserve his relationship to the world and to his art. He has remained true to his own way of seeing, and as a result his art and his life have been inextricably bound together in his photographs.

Though as a youth he had no pretentions about making "great art," Kertész nevertheless got off on the right foot when he determined to please himself. He could easily have imitated the photographs of the early twentieth-century soft-focus salon portraits and landscapes, but he realized intuitively that such pictures tampered with the real nature of their subjects. From the start he was more interested in depicting facts than in inventing fictions.

This task was not an easy one. Kertész was drawn not to particularly lofty subjects, but rather toward representing the true and fragile nature of the existing world without altering it. The camera was the perfect instrument, a seemingly dispassionate recorder reaching toward reality. And so Kertész, long before photography was a fashionable profession, and against his family's preference that he become a banker, set out to look at the world and to contemplate it with the greatest attention and respect. At first he would explore; innovation was to follow.

It was 1912 when he bought his first camera, an ICA box-type. For the next thirteen years he photographed people he met by chance and those he knew well, places he frequented, and events, such as World War I, in which he was at once an involved participant and an objective observer. Except for those of the war, his early pictures were taken mostly in and around Budapest, his birthplace. Though many of them were lost in the Hungarian Revolution of 1918, the few that survive show his disinterest in the drama and elegance of the city that was called "the Paris of Central Europe." Instead, he ruthlessly chose to record the simple, quintessential Hungarian moments that he deeply felt.

As he explored his everyday world, he came, probably without realizing it, to have another subject: photography itself. He loved the medium's versatility, and he tried everything. Instead of working only on bright, clear days, he photographed in all kinds of weather—anxious to see what the camera recorded when it rained or snowed, when there was an abundance of light or a virtual lack of it. In one early picture (1921), dark figures lurch across the wet cobblestone streets of a Budapest square drenched by a sudden spring shower. In another, taken on an autumn afternoon, a single horse-drawn cart pushes its way through the heavy November fog. Others were taken on snowy days; many, at night. He also concerned himself with time—not just with freezing the significant moment, but with capturing the sense of time passing, the act unfolding, the feeling of movement.

He found no need to manufacture pictures or to force responses when the richness of the world was so plainly visible, and the camera so capable of capturing it. Thus his pictures began to take individual form, to record what his eye instinctively found to see. As such, they were not crystal-clear renditions of the world. Visually, abstractions began to take shape as photographic detail was sacrificed to capture the essence of a moment. These were the fruits not of happy accident, but of conscious choice.

In 1925 Kertész left Budapest for Paris. The move was a manifesto, a natural, well-timed declaration, and only in the smallest sense was it a risk. The time had come for him to exchange a shaky business career for that of a committed artist. Since 1912 he had been photographing whenever he could, in between jobs at the Stock Exchange. His photographs had been published in the illustrated Hungarian magazines. He was thirty-one years old, sufficiently confident of his abilities, clearly aware of his own value, and ambitious to extend his limits. In Hungary he lacked the supportive atmosphere of an artistic community; in Paris, perhaps, he could live his life rather than continually have to explain it.

Kertész had intuitively grasped that the camera could be used in direct response to how he felt about the world; now he was ready to explore his art on another level. In Paris he was able to give reign to his intellectual, even analytical and self-conscious sense of form. In the same way as he had roamed the Budapest countryside, he stalked the streets of Paris. He pointed his camera everywhere: upwards across rooftops, into windows, taking in entire façades or selecting out small details; downwards onto sidewalks speckled with people working themselves into patterns, merging with cement curbs, cobblestones, edges of trees, and slices of buildings. Vantage point became important. And each time he made a picture he learned a bit more about the city that was now his home.

Everything seemed to work for him. Even though a photographer ranked, perhaps, with a gypsy fortuneteller in this art capital of the world,

when the artists of Paris saw Kertész's work there was a stirring of interest. And it was they who were the first to recognize his unconventional pictures.

His first show was in 1927 at the Sacre du Printemps, a small, innovative modern art gallery on the Left Bank. The critics were generous in their praise, and Kertész was invited to show in the First Independent Salon of Photography. He was courted by editors and virtually given his choice of assignments. His free-lance reporting paid his way. He exhibited, published books (three in as many years), and was a major contributor to the leading German magazines (*Frankfurter illustrierte* and *Berliner illustrierte*) and to their French counterparts (*Vu* and *Art et Médecine*). European museums began to collect his work. By the time he was forty years old, in 1934, he was venerated as a master of the photographic medium.

His friends in Paris were the revolutionary artists of their day: Mondrian, Léger, Chagall, Vlaminck, Lurçat, Calder, Eisenstein—each in revolt against art, morality, and society. And Kertész joined them in the celebration that was Paris between two world wars. Quickly he was accepted as a member of the avant-garde scene that centered around Montparnasse. It was a spontaneous life, a happy one that seemed all the more intense because art and life were so pressed together.

For a short time he worked on a series of nude distortions that he had begun in Hungary years before. Eventually he determined that he could see no further development in the work. Still, there were over 150 innovative pictures that were rich in their surrealistic qualities. Even more than in his street pictures, there was a sense of life as a dream. The surrealistic concept of transforming reality into fantasy made its way into Kertész's technique. His work came to influence his friends' paintings.

As he was stimulated by the ideas of artists around him, his pictures grew less sentimental and more sophisticated. They became highly refined, sensitive observations of the abstract relationships between curves, angles, light, and shadow. And because of his sensitivity they were as beautiful, or surprising, or whimsical as they were firmly rooted in the everyday world. It was an atmosphere in which Kertész thrived.

In 1937 Kertész decided, against the advice of friends, to leave Paris for New York City to work on a contract he had been offered by Keystone Studios, a major picture agency of the time. When he terminated the contract with Keystone eight months later, World War II was pending; a return to Paris was not only impractical but impossible. For the first time in his life there was no choice: America was to become home, at least temporarily.

Kertész, with his reputation, his portfolio of pictures and books haphazardly collected for the trip, was eager to work. He found himself in a country that was excited by photography as a means of personal expression and as a modern means of communication. His talent as a major

European photographer and his understanding of subjective reportage with a 35mm camera should have guaranteed him employment. But from the beginning his European sensibilities were to clash with those of the American editors excited by their own talent for invention, and with earnest young museum directors making their first attempts at accounting for the phenomenon of photography—a medium in which Kertész had worked for some twenty years.

He was told by the editors of *Life,* when he visited their offices, that his pictures "spoke too much." What they meant was, his work did not need their highly polished words. It was profoundly symbolical, whereas *Life* wanted to pinpoint the world clearly in its readers' minds almost as though it were a newspaper. Moreover, when shooting for European picture magazines (the prototypes for *Life*), Kertész had always managed to cover the assignments in six to twelve pictures. Such frugality only squelched the *Life* editors, who were accustomed to a wide sample from which to select the right picture to combine with the right words. This relationship was totally at odds. It could satisfy neither party, and so Kertész never worked for *Life.*

Yet photography by 1937 had indeed arrived in America. That year Edward Weston received the first Guggenheim grant ever given to a photographic artist, and Weston himself exemplified the American photographic movement. His approach to picture-making was direct. It was a relationship founded on respect, at the very least, and perhaps love of the mechanistic characteristics of photography. Unlike Kertész, who worked gingerly with a 35mm camera, Weston used a large-format camera, the smallest aperture opening, and long exposures. Thus he was able to achieve photographs characterized by unusual depth of field and brilliant definition of detail. Kertész, on the other hand, never cared for extreme sharpness or for definition of detail. His choice of the 35mm camera enabled him to capture the expression of the moment. Although both Weston and Kertész allowed the subject its own authority, each came to the subject with an altogether different set of sensibilities. If Weston's rendition of the world was epic and his clean, unblurred pictures awesome, Kertész's work was consistently moving because his photographs mirrored the fragile, evolving nature of all human experience.

So Kertész, whose photographs were too subjective and evocative for the picture magazines of the day, found himself out of step, for neither did he fit in with the community of American photographic artists who were set on defining a highly intellectual, peculiarly American aesthetic.

Although the first major photography show at The Museum of Modern Art in 1937, "Photography, 1848–1937," represented Kertész by five photographs, it was to be his last until 1946, when the Chicago Art Institute honored him with a one-man show. He had come to America when the country was getting acquainted with photography, but he would have to wait until the Americans found their sure footing in photographic

terms. Then, decades later, they would turn to him, demanding to know where he'd been all along. They would discover him for themselves.

During those years in between, Kertész freelanced for *Harper's Bazaar, Vogue, Town & Country, Collier's, Coronet,* and *Look.* Eventually he signed an exclusive contract with Condé Nast Publications, which provided a livelihood for him and his wife, Elizabeth, over the next thirteen years. He continued working isolated from the mainstream of critical acceptance. He became a master at straddling both worlds. When he did commercial assignments for *House & Garden,* he also carried his Leica. During breaks in the shooting sessions, he made his own pictures. In short, he survived. Under these conditions, although he did not add substantially to his major body of work, his eye did not move from its belief.

Kertész was seventy years old when in the 1960's American curators finally took note of his presence. John Szarkowski mounted a major one-man show at The Museum of Modern Art in 1964. Thus began a series of exhibitions which have continued into this decade. Kertész at last had come into his own.

Although Kertész's world has been in a continual state of flux, the center of that world—his one-to-one relationship with his subjects and his art—has remained secure. Never did he veer from that truthful plane in order to please his peers or to elicit recognition. His photographs, then, reveal a whole world at once expected and unexpected to anyone who examines them.

Carole Kismaric

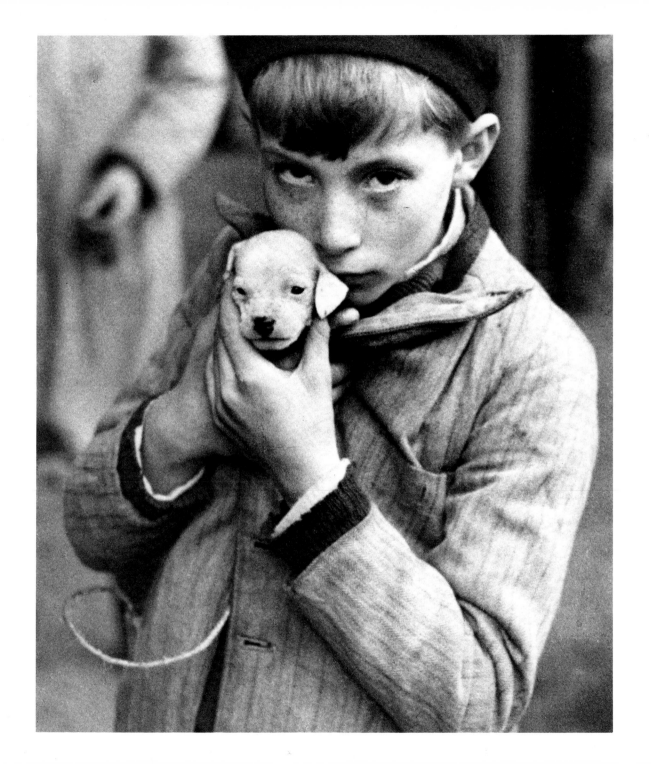

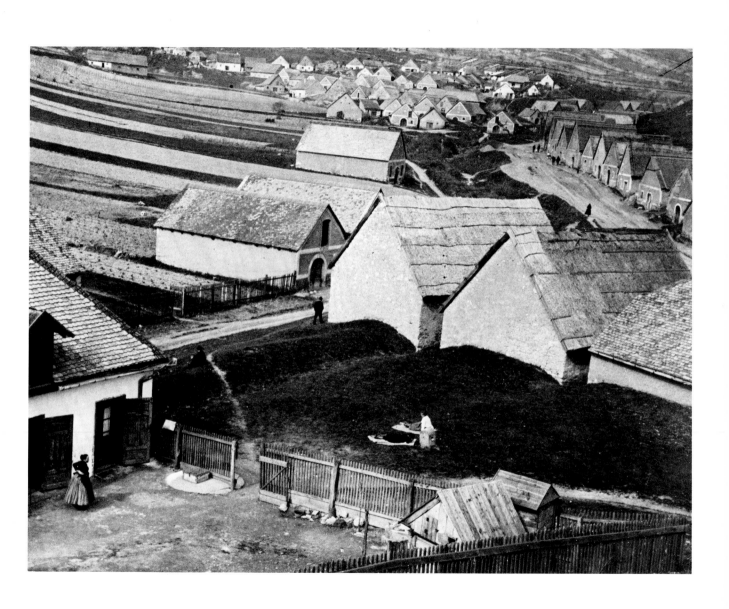

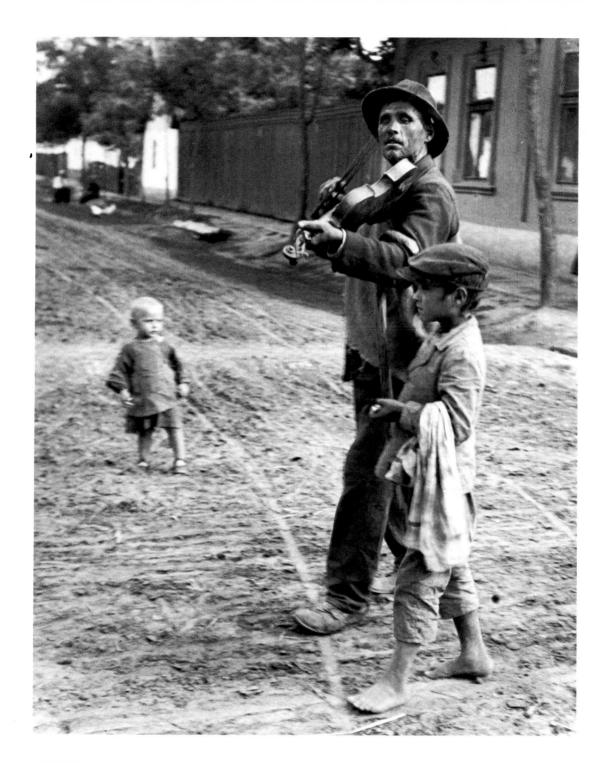

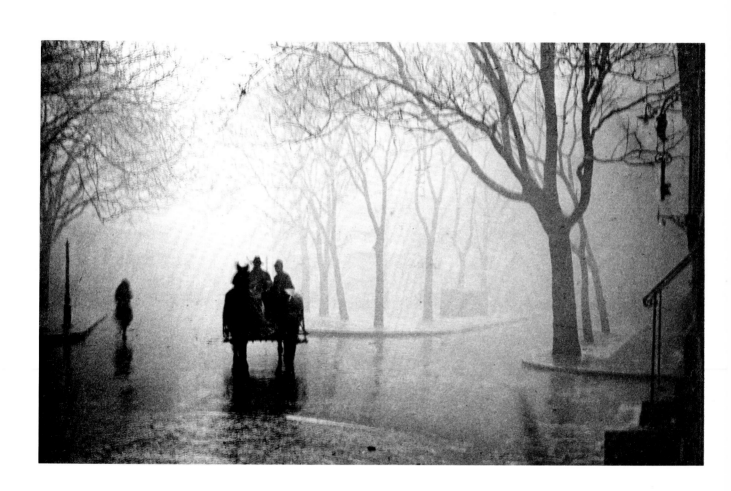

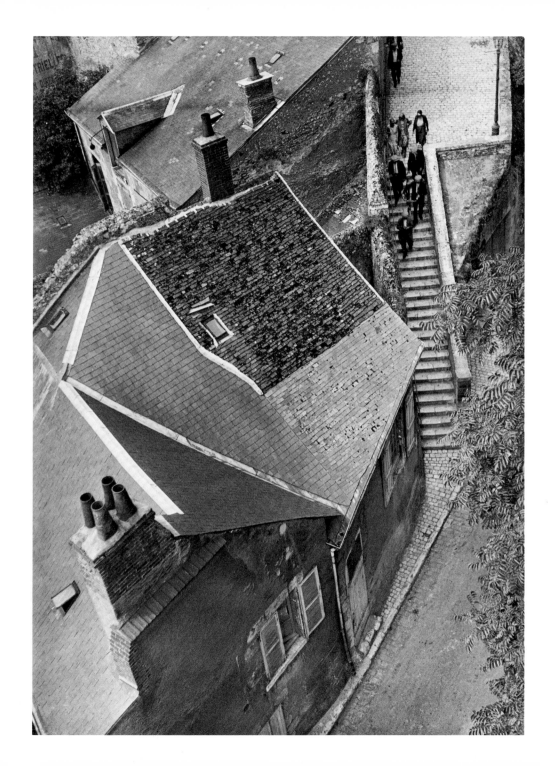

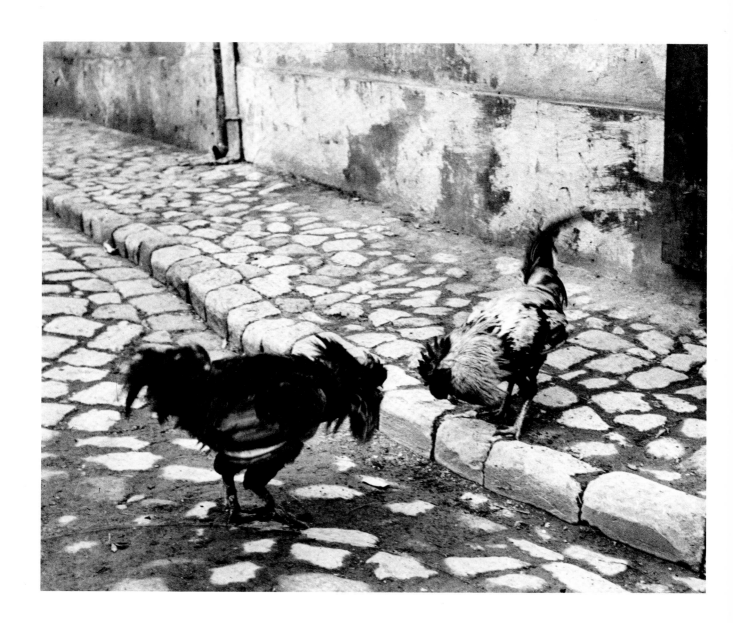

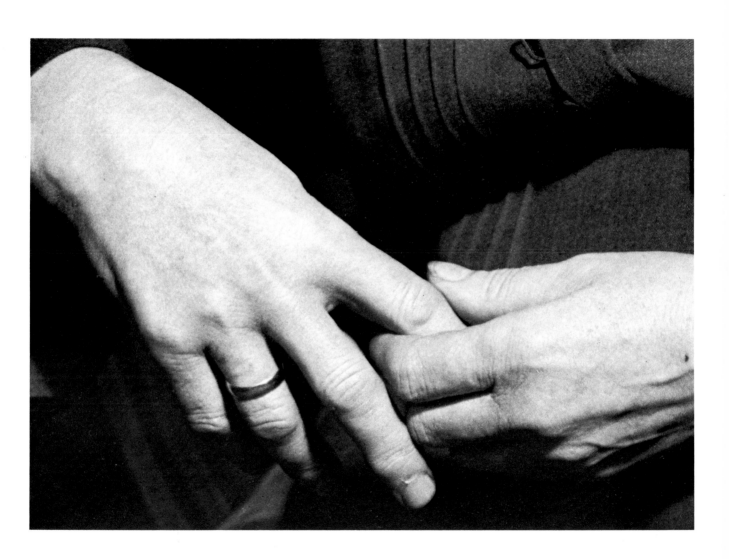

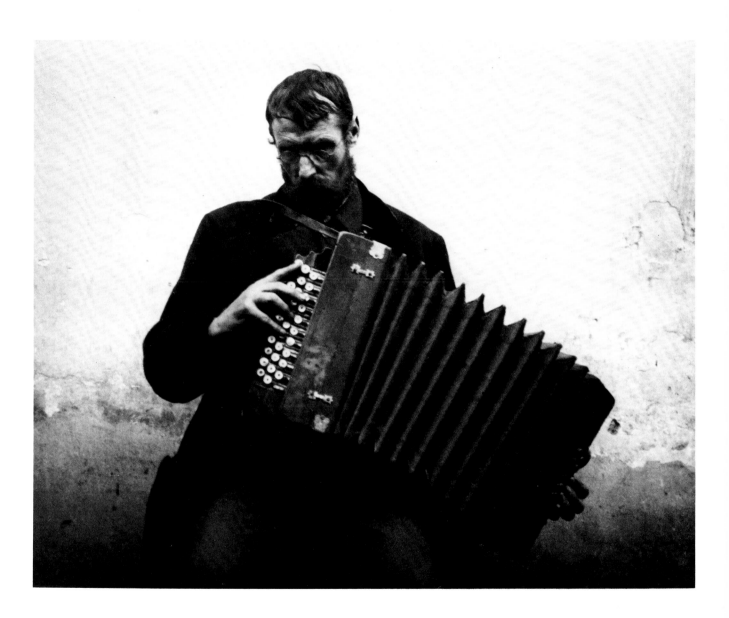

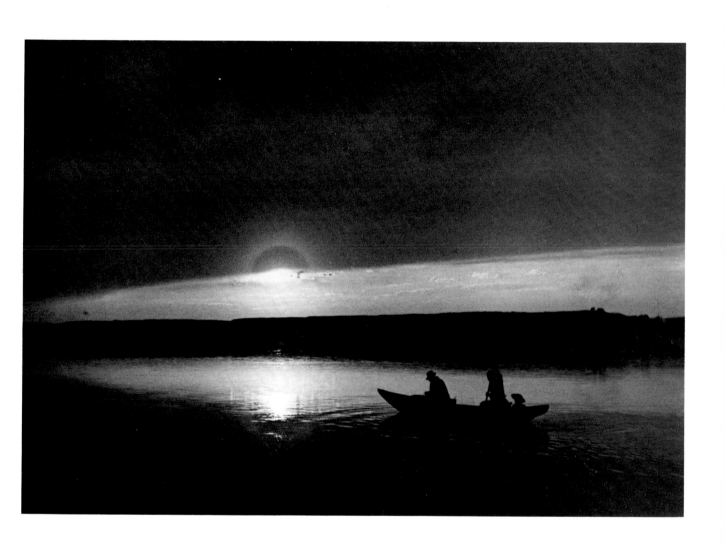

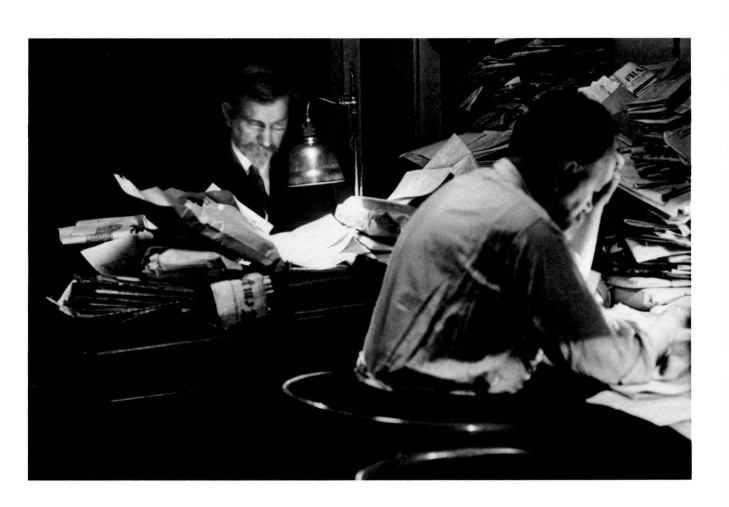

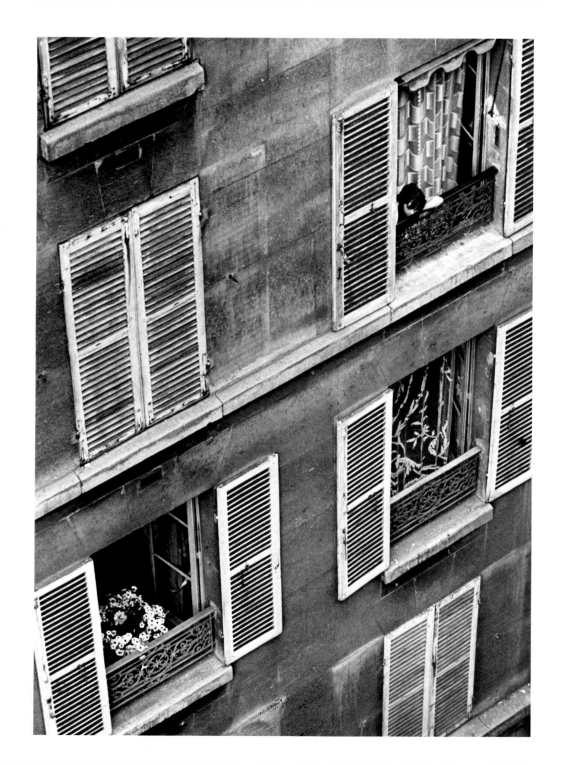

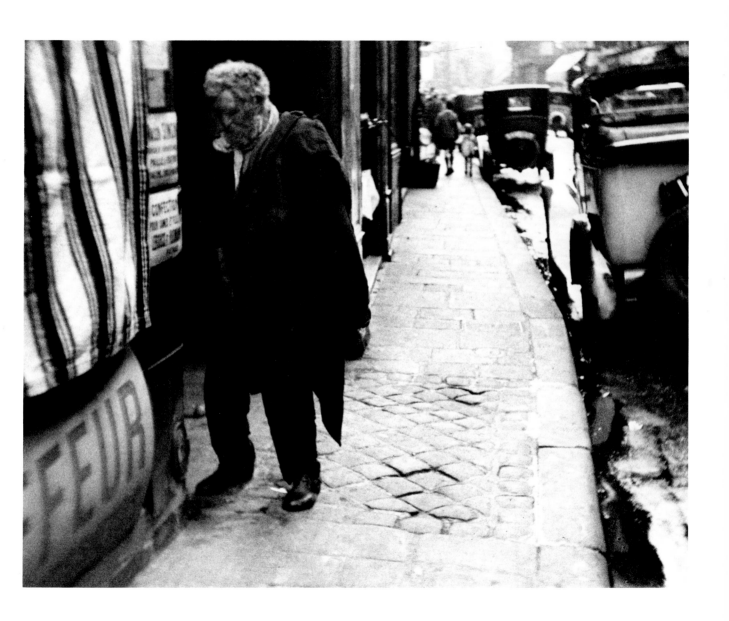

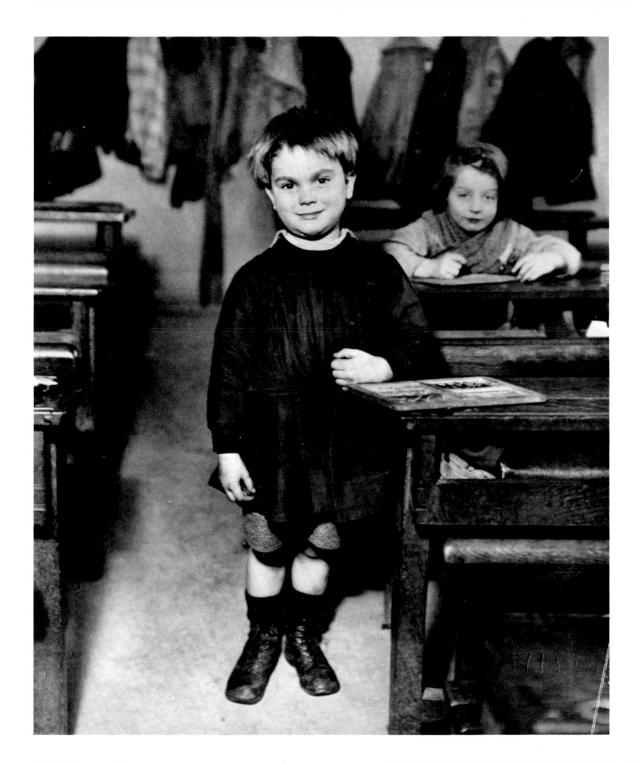

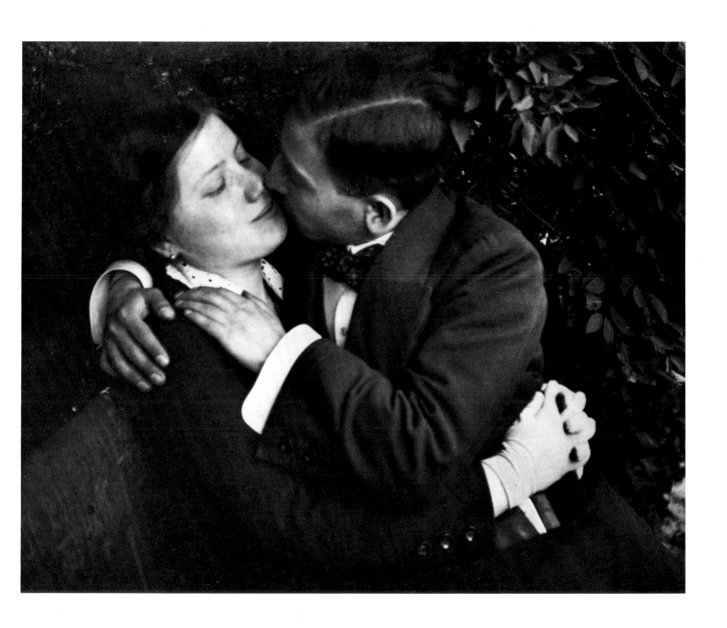

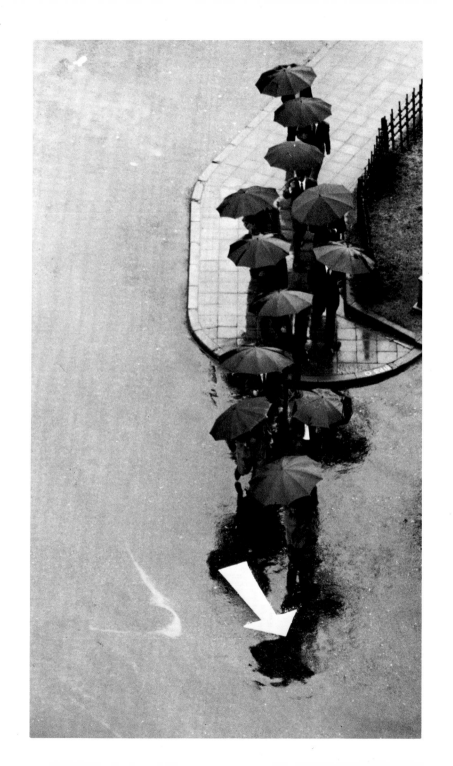

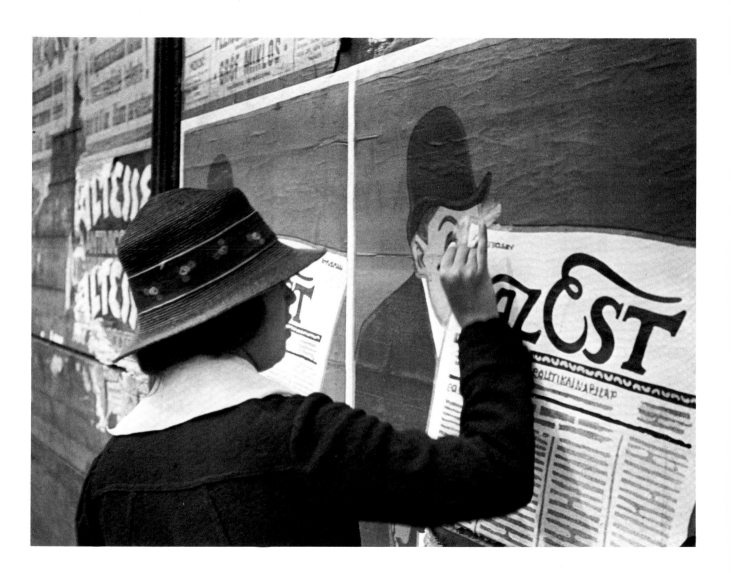

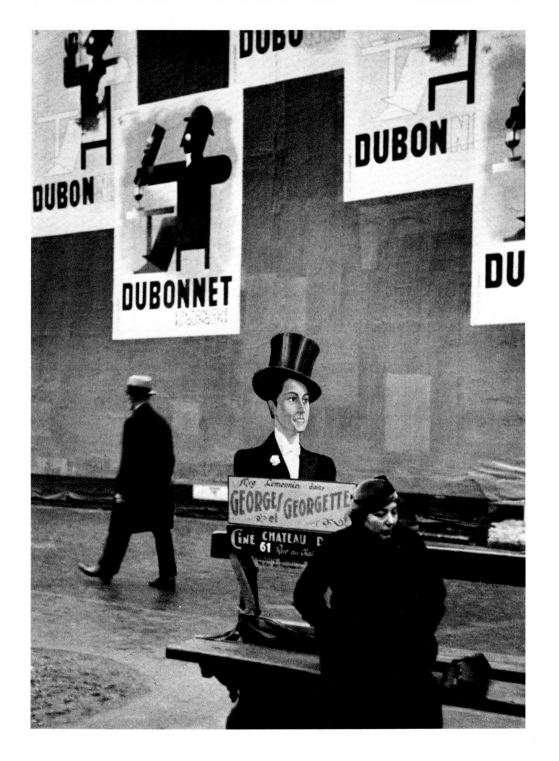

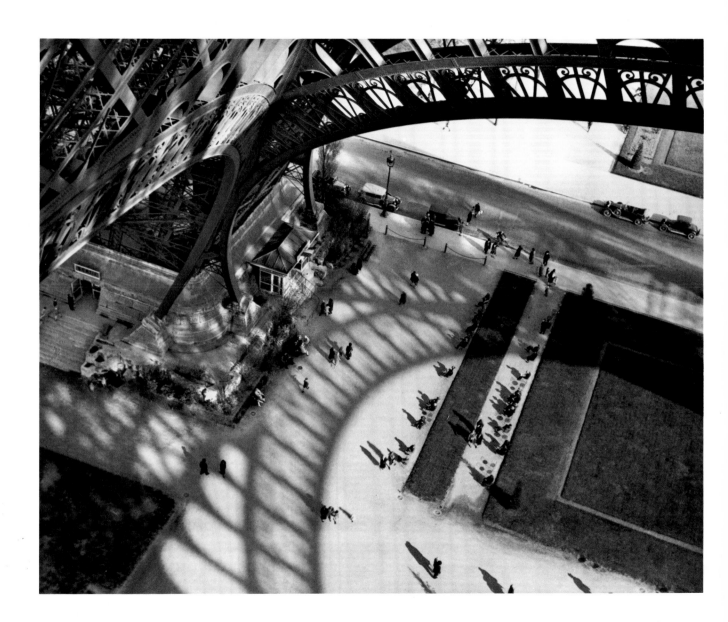

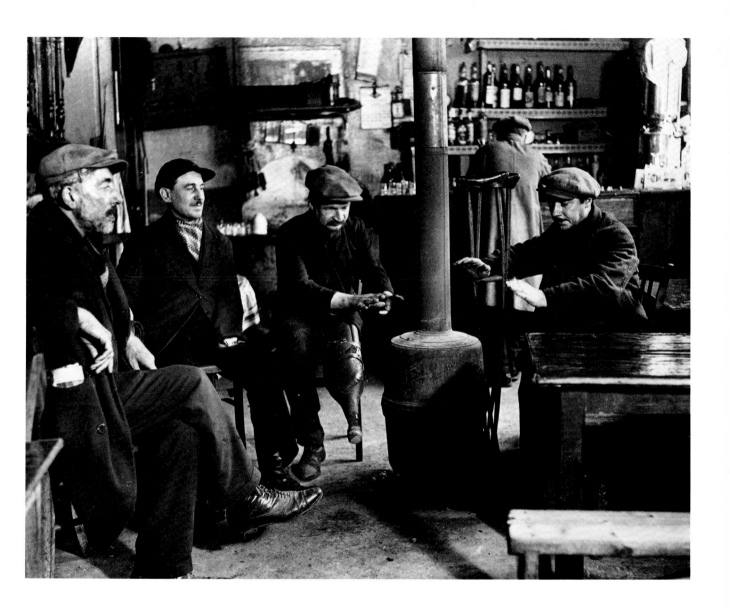

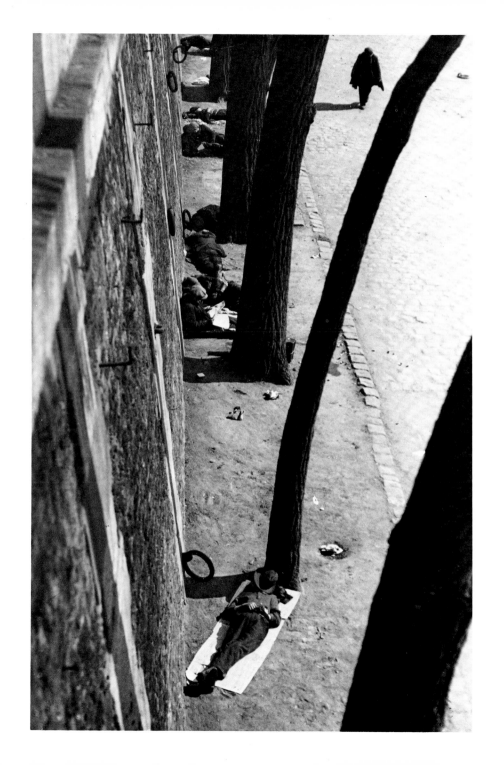

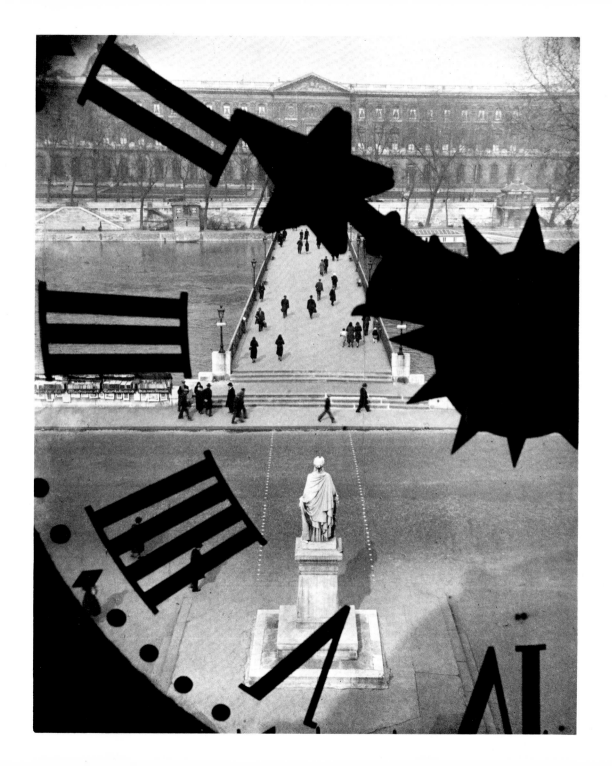

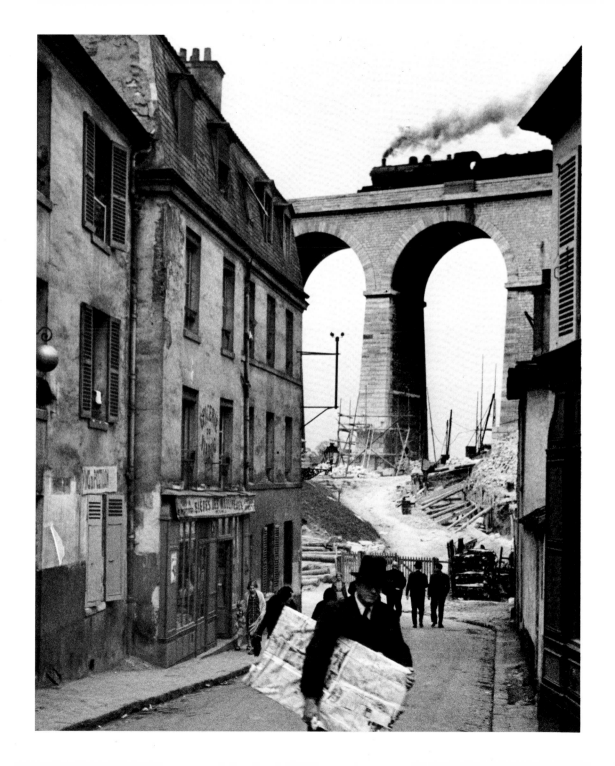

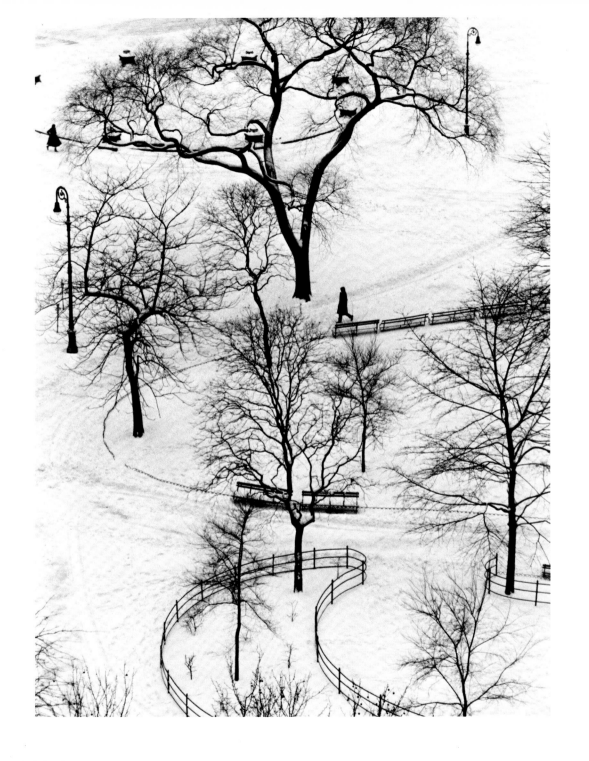

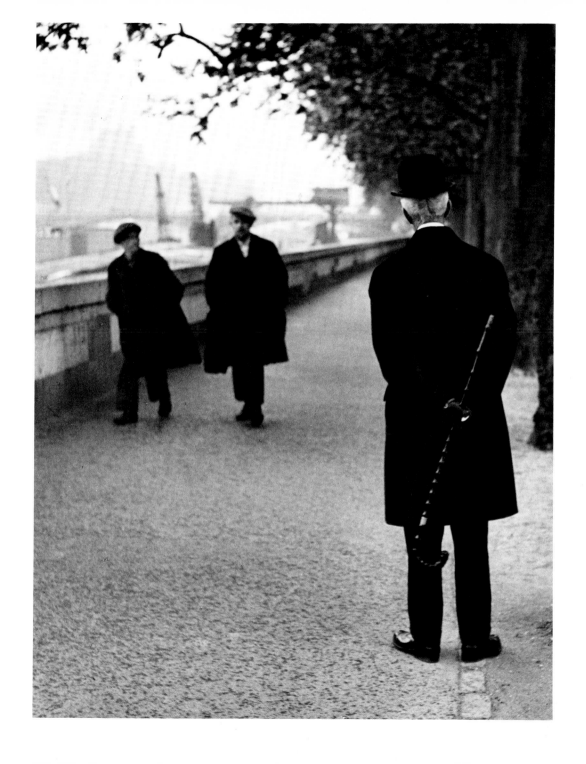

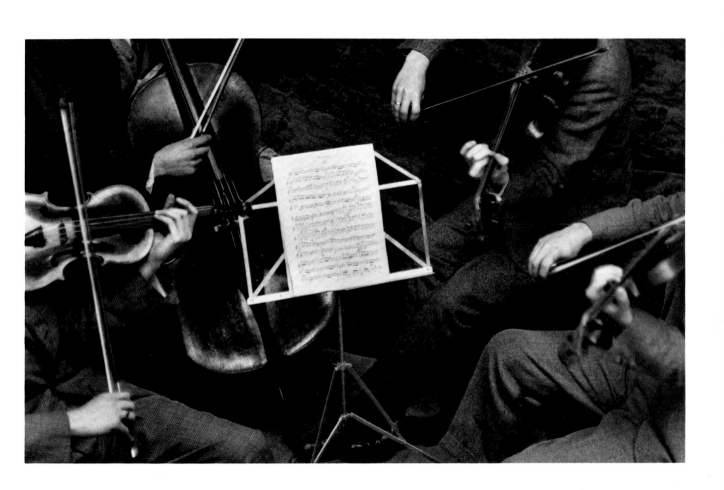

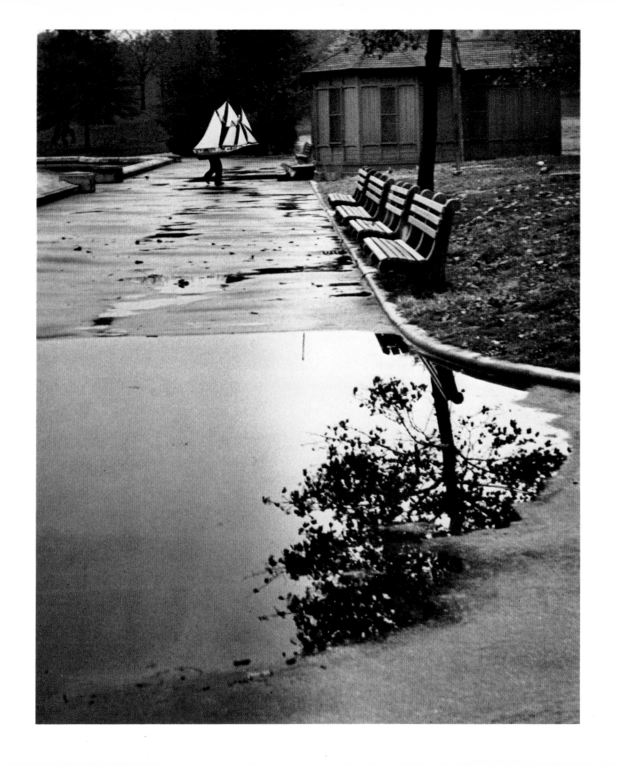

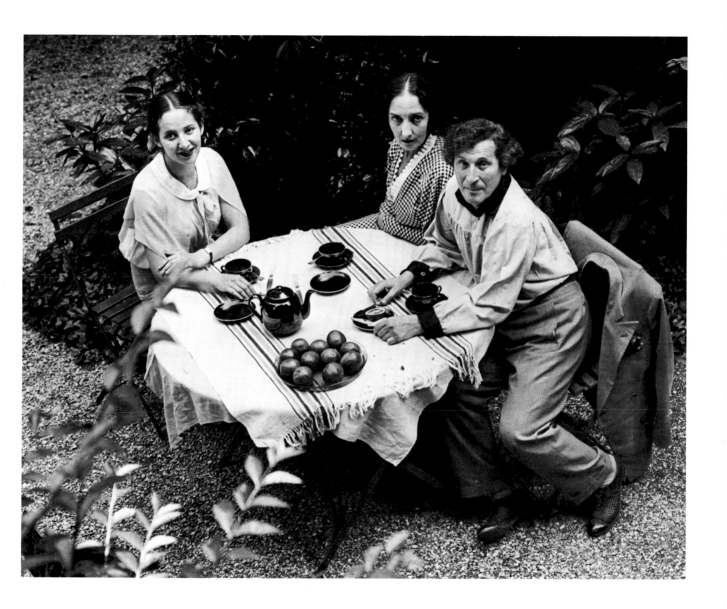

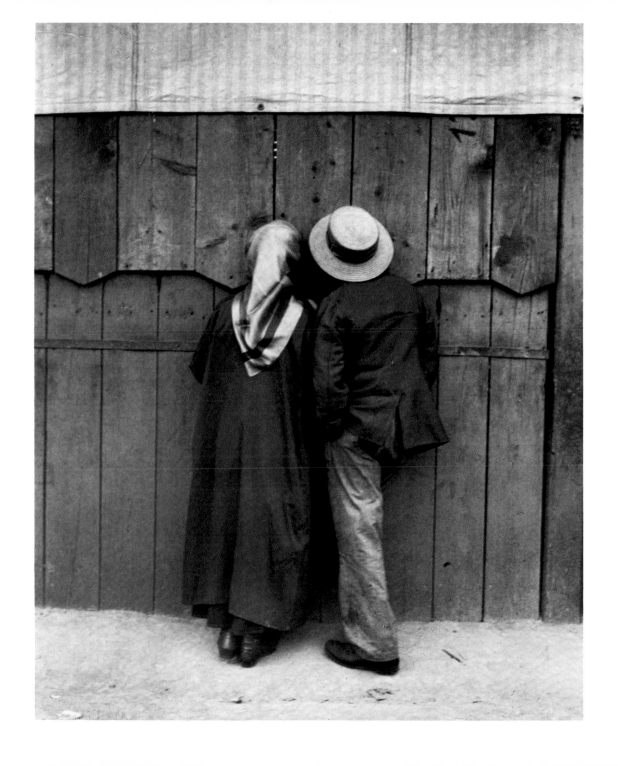

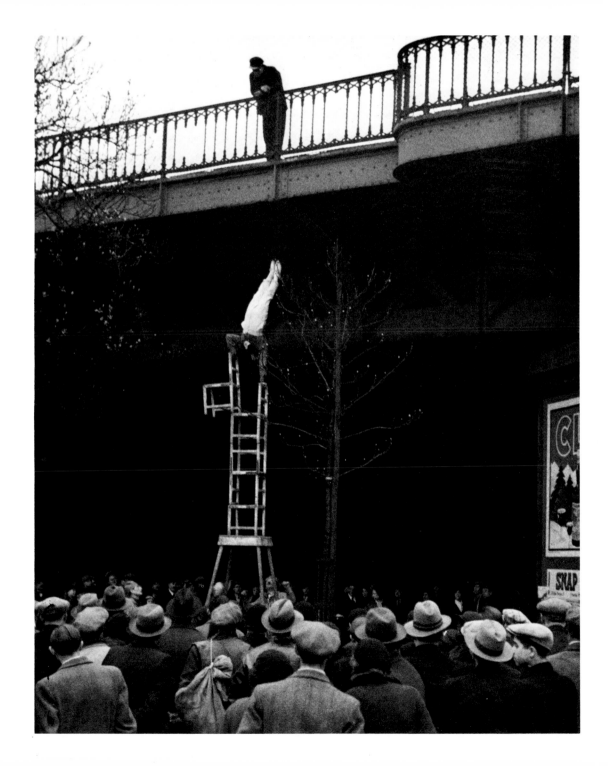

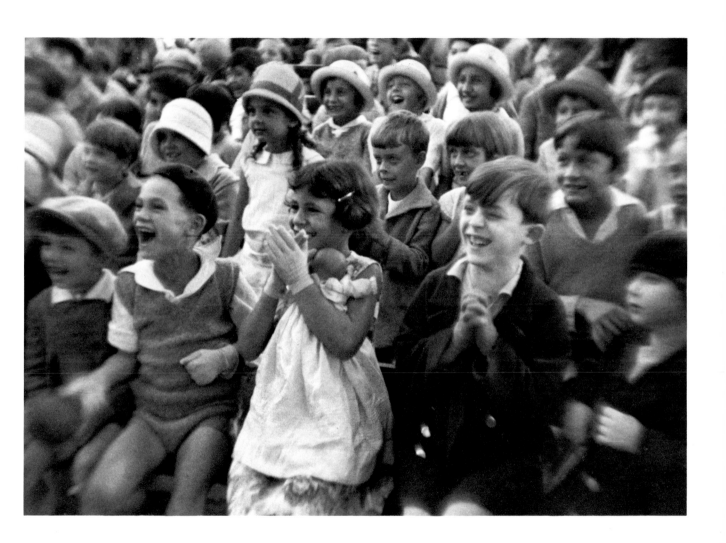

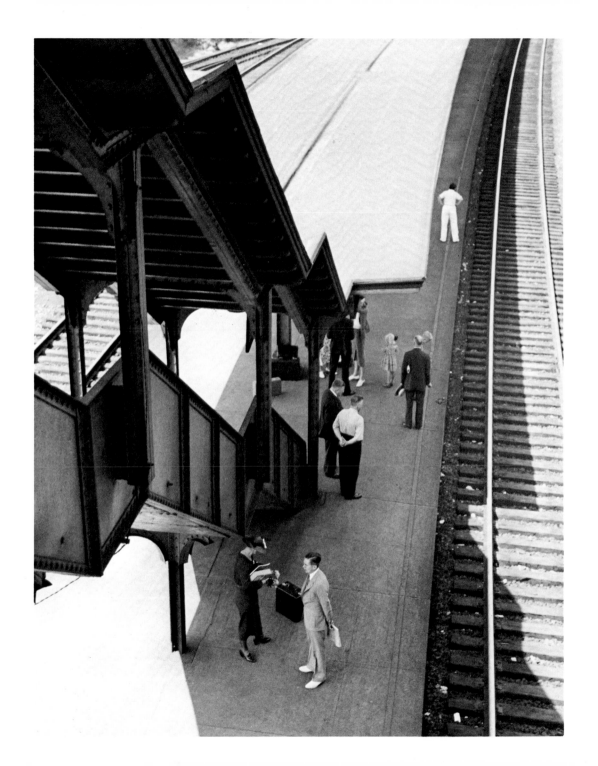

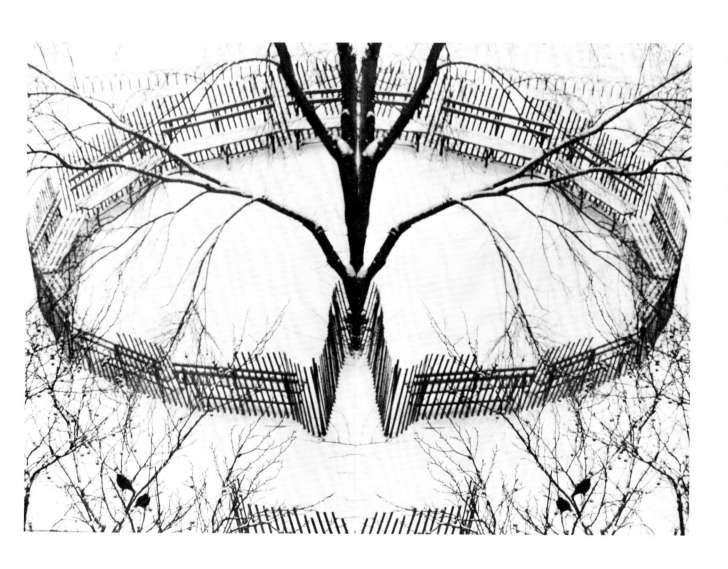

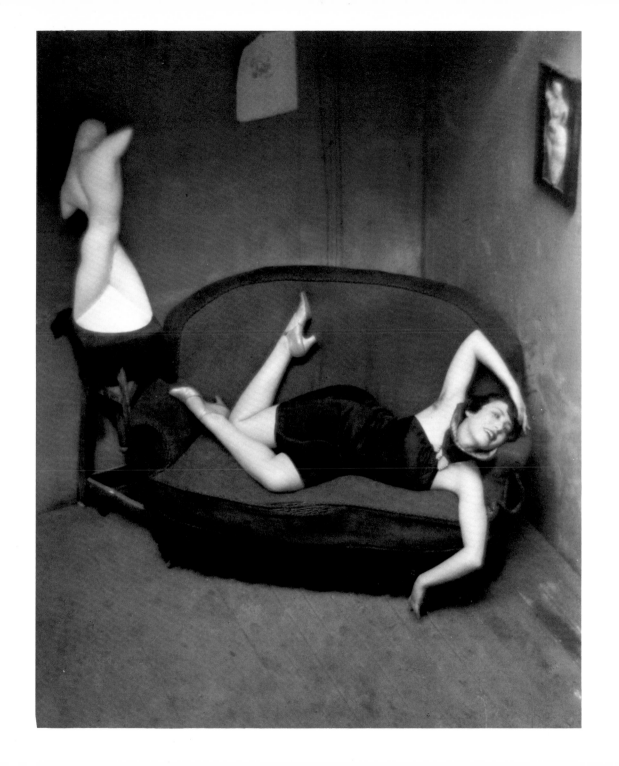

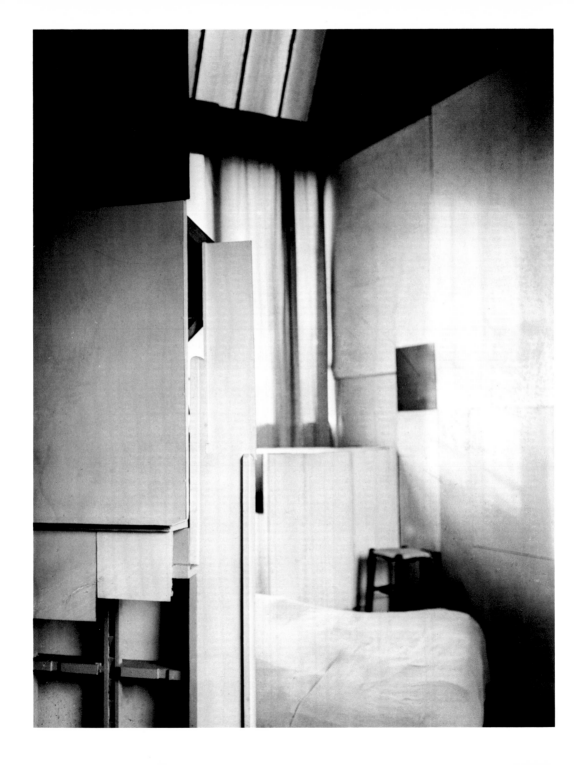

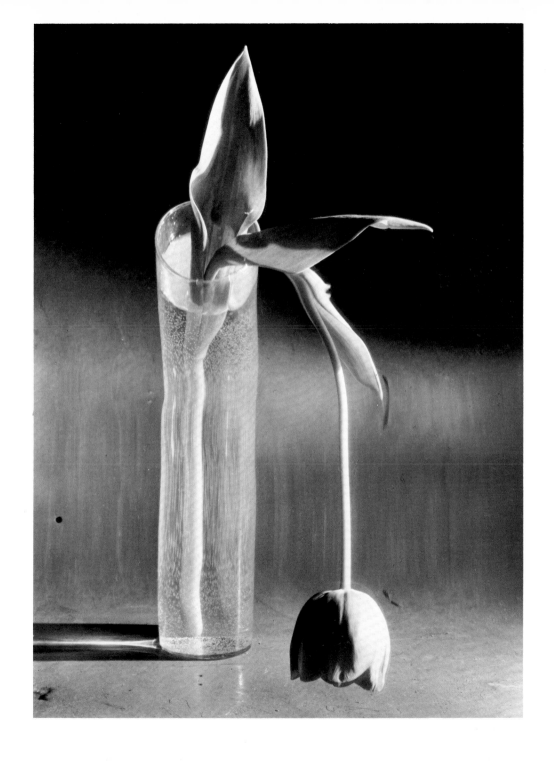

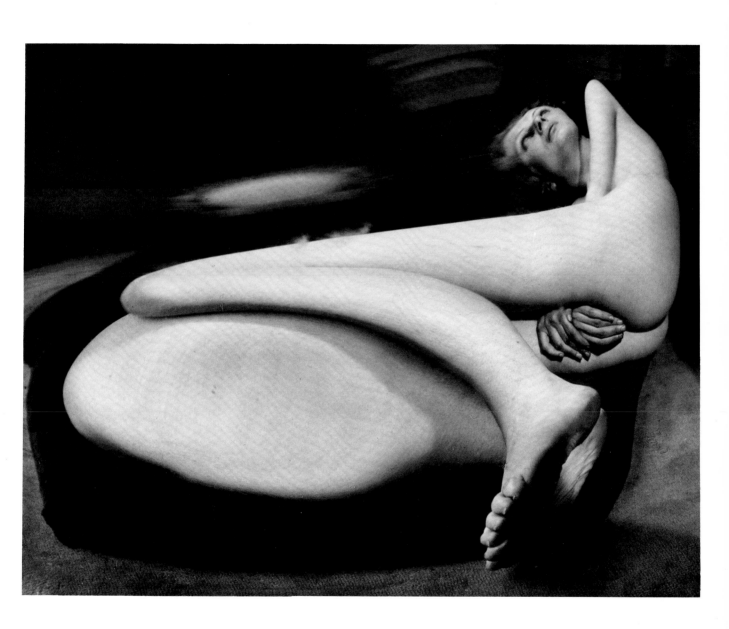

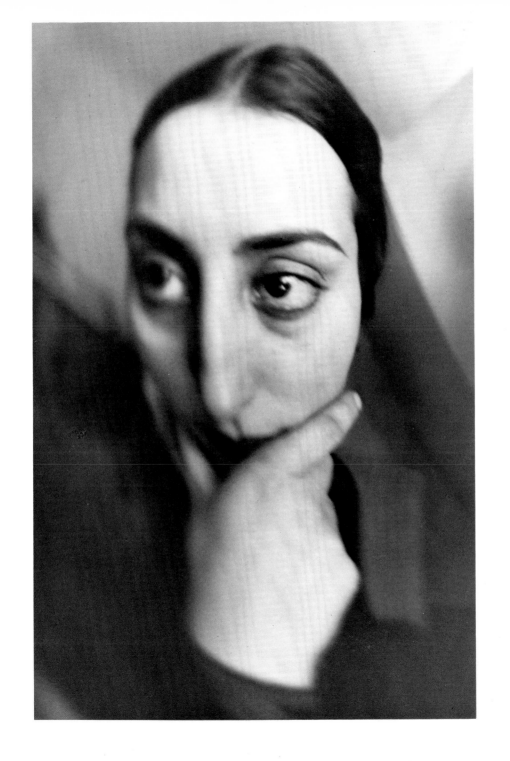

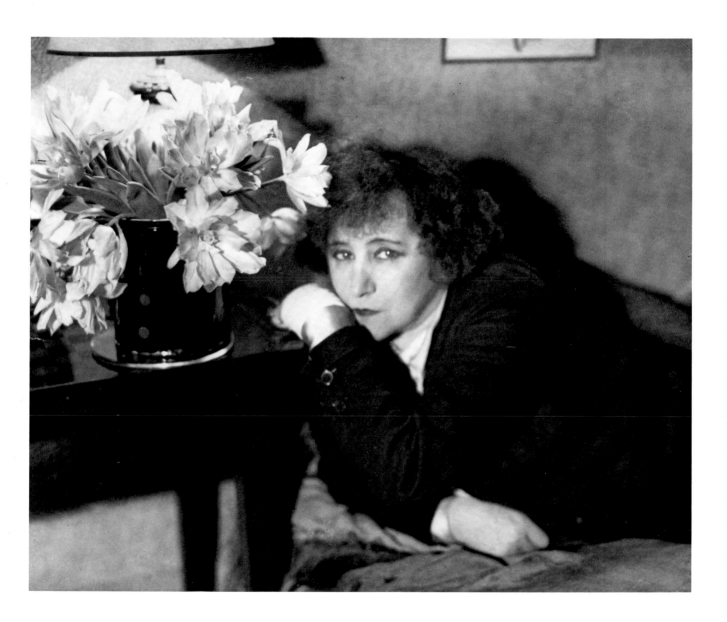

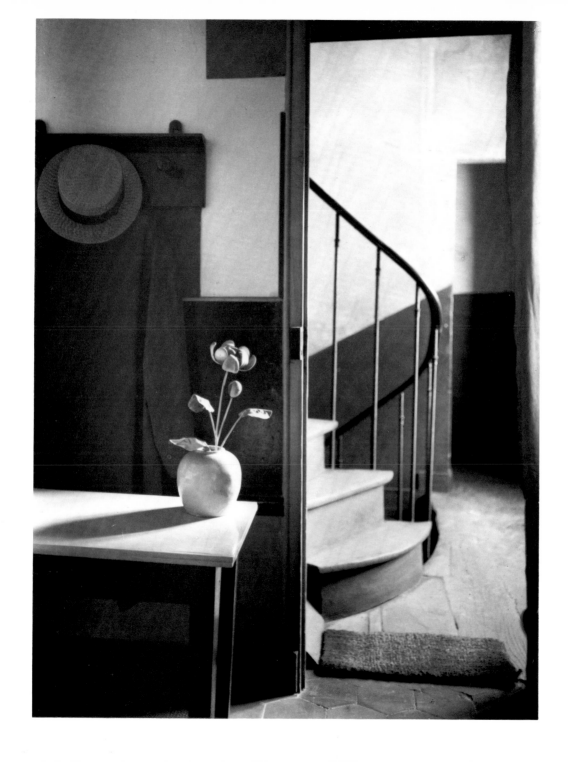

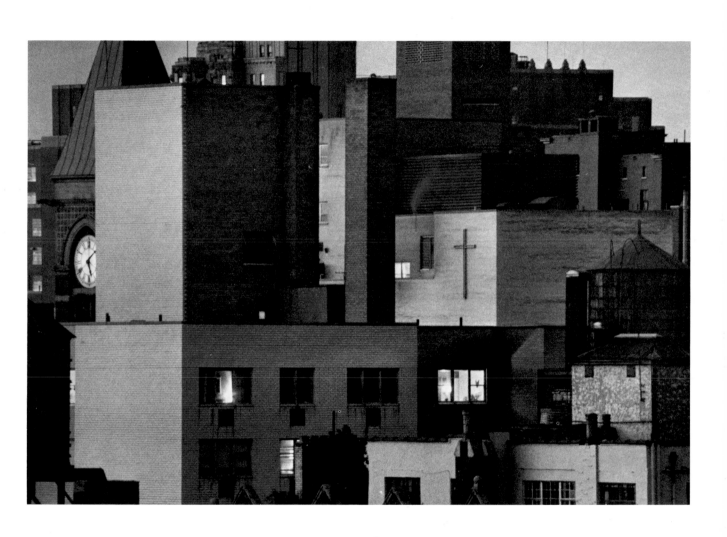

PHOTOGRAPHS

BRIEF CHRONOLOGY

1894 André Kertész born 2 July, Budapest, Hungary, to Jewish middle-class Hungarians. Father dies when he is fourteen.

1911 Begins photographing around Budapest and on family outings in the country.

1912 Receives baccalaureate from Academy of Commerce, Budapest; works as clerk in Budapest Stock Exchange. Buys first camera, ICA box-type, and photographs candid street scenes, genre subjects.

1914–18 Serves in Austro-Hungarian army; wounded in 1915. Makes photographs of war and the communes with Goerz Tenax camera.

1916 Receives prize for satiric self-portrait from *Borsszem Janko* magazine.

1917 Publishes photographs in *Erdekes Ujság,* a news magazine.

1925–28 Moves to Paris. Free-lances for *Frankfurter illustrierte, UHU* magazine, *Berliner illustrierte, Strassburger illustrierte, Le Nazione Fiorenze, Vu,* London *Times,* among other publications. Meets other Hungarian writers, artists, journalists, and composers—Noémi Ferenczy, Jozef Csaky, Brassaï—who have

settled there. Becomes acquainted with American and European artists working in France, such as Man Ray, Chagall, Brancusi, and Mondrian.

1927 First exhibition held at the Galerie au Sacre du Printemps.

1928 Buys first Leica. Marries Rosza Klein, a portrait photographer. They live together at 75, Boulevard du Montparnasse, but separate two years later.

1929 Photographs are purchased for collections of Staatliche Museen Kunstbibliothek, Berlin, and Konig-Albert Museum, Zwickau.

1930 *Art et Médecine* begins publication; Kertész is a major contributor until 1936.

1931 American debut of his work appears at a New York Art Center exhibition. Moves in with Elizabeth Saly.

1933 Returns to Budapest for his mother's funeral. According to Kertész, he marries Elizabeth. His first book, *Enfants,* is published in Paris.

1936 Arrives in New York under contract to Keystone Studios, a photo agency.

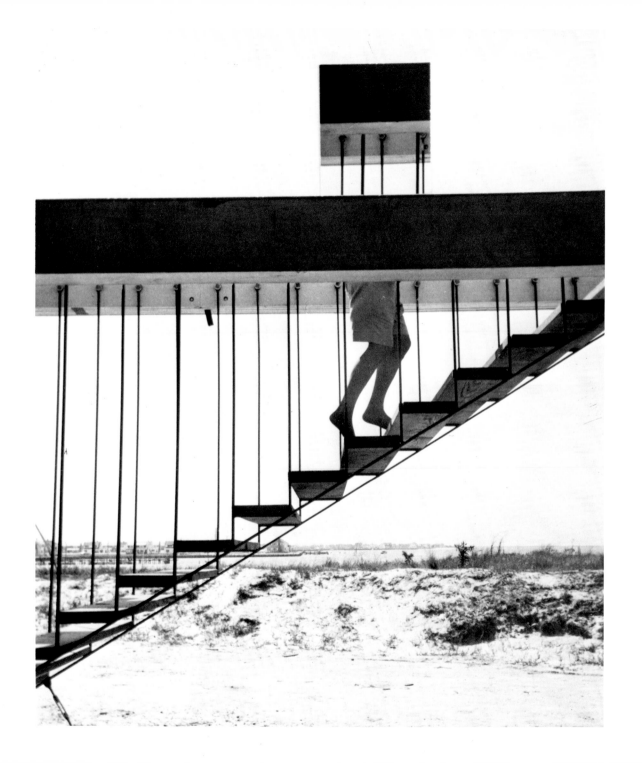

1937 First one-person exhibition in New York, held at P.M. Galleries. Terminates studio contract and starts to photograph views of New York on his own. Alexey Brodovitch, whom he had met in Paris, gives him an assignment for *Harper's Bazaar*.

1937–49 Free-lances for *Vogue, Town & Country, American Magazine, Collier's, Coronet, Look*.

1941–44 War years intervene. As a foreigner, Kertész is considered an "enemy alien" and is fingerprinted. For four years, no work appears in magazines.

1944 Becomes an American citizen.

1949–62 Signs exclusive contract with Condé Nast publications; terminates contract after thirteen years.

1965 Receives Honorary Membership in ASMP, American Society of Magazine Photographers.

1974 Receives a John Simon Guggenheim Memorial Fellowship, which he uses to have his glass-plate negatives, badly oxidized, restored.

1977 Elizabeth dies of cancer.

1980 After 1980, no longer photographs on streets of New York, but continues to photograph in his apartment and from his windows, as well as when traveling.

1982 Receives National Grand Prize of Photography in Paris.

1983 Receives Chevalier de la Légion d'Honneur in Paris. Apartment is set up by the French Government for subsequent visits to Paris.

1984 Metropolitan Museum of Art acquires over one hundred vintage Kertész prints of New York, the largest museum purchase of photographs by a living artist.

1985 The Hungarian village of Sziget Becse establishes permanent home for Kertész's work. He donates selection of early work for permanent exhibit. Travels to Japan, Santa Fe, and Buenos Aires. September 28, dies at home in his sleep. His body is cremated and his ashes are interned with those of Elizabeth.

MAJOR EXHIBITIONS

1927 One-person show, Sacre du Printemps Gallery, Paris, March 12.

1928 Included in First Independent Salon of Photography, Paris.

1929 Included in The International Ausstellung von Film und Foto, Stuttgart.
Included in Fotografie der Gegenwart, Essen.

1930 Included in Salon de l'Araignée, Paris, and in the traveling show originating in Essen, Germany, "Das Lichtbild."

1931 American debut at "An Exhibition of Foreign Photography," at New York Art Center.

1932 Thirty-five prints in Julian Levy's New York gallery show "Modern European Photography."

1934 Included in group show at Leleu's Paris group show.
Included in group show at Galerie de la Pléiade, Paris.

1936 Included in Musée des Arts Décoratifs exhibition, Paris.

1937 First one-person exhibition in New York at P.M. Galleries.
Included in "Photography 1839-1937," at the Museum of Modern Art, New York, curated by Beaumont Newhall.

1941 Included in "Image of Freedom" exhibition at Museum of Modern Art, New York.

1946 One-person show, Art Institute, Chicago

1962 One-person show, Long Island University, New York.
Included in Fourth Mostra Biennale Internazionale della Fotografia, Venice.

1963 One-person show, Bibliothèque Nationale, Paris.
Included in small exhibit at Modernage Photo Lab in New York.

1964–65 One-person show, "André Kertész: Photographer," Museum of Modern Art, New York, curated by John Szarkowski.

1967 Group show, "The Concerned Photographer," opens at Riverside Museum, New York, and travels internationally.

1970 Exhibit of ten photographs, U.S. Pavilion, World's Fair Exp '70, Osaka, Japan.

1971 One-person show, Moderna Museet, Stockholm.
One-person show, Magyar Nemzeti Galeriaban (Hungarian National Gallery), Budapest.

1972 One-person show, Valokuvamuseon, Helsinki, Finland.

1973 One-person show, Hallmark Gallery, New York.
One-person show, Light Gallery, New York.

1976 One-person show, Wesleyan University, Middletown, Connecticut.
One-person show, French Cultural Services, New York.

1977 Retrospective exhibition, "André Kertész," at the Musée National d'Art Moderne de Centre Georges Pompidou, Paris.
Included in Documenta 6, a multimedia art exhibition, Kassel, West Germany.

1978 Joint exhibition with Charles Harbutt at the Plains Art Museum, Moorhead, Minnesota.

1979 Arts Council of Great Britain hosts exhibition at Serpentine Gallery, London.
Exhibition at Kiva Gallery, Boston.

1980 "Prints of a Lifetime," 297 prints from the Norwest Holst,

Ltd. Manchester England Collection at the Israel Museum. Exhibited at Gaillard Gallery, France.

1981 One-person show, Susan Harder Gallery, New York. One-person exhibit of Washington Square photographs, Grey Art Gallery, New York University, New York.

1982 "André Kertész, Master of Photographs," Chrysler Museum, Norfolk, Virginia, curated by Brooks Johnson. One-person show of vintage Hungarian prints, Susan Harder Gallery, New York.

1984 Retrospective Exhibition at the National Museum of Photography, Film and Television in Bradford, England.

1985 "André Kertész: Of Paris and New York," 192 images from 1925 to 1954, the Art Institute, Chicago, in conjunction with The Metropolitan Museum of Art, New York. Exhibition of new work, 1980–1984, Edwynn Houk Gallery, Chicago.

Exhibition at Jacksonville Art Museum, Florida.

Permanent exhibit established in Sziget Becse, Hungary.

Exhibit of 173 photographs at Printemps in Tokyo organized by the International Center of Photography.

"Diary with Light," Ernesto Mayans Gallery, Santa Fe.

Exhibition at Museo Nacional de Bellas Artes, Buenos Aires.

1986 "André Kertész: Of Paris and New York," at the Metropolitan Museum of New York, travels to Palais de Tokyo.

1987 Retrospective exhibition at the International Center of Photography, New York.

SELECTED BIBLIOGRAPHY

Books by André Kertész

Enfants. Sixty photographs of children. Text by Jaboune. Paris: Éditions d'Histoire et d'Art, 1933.

Paris Vu par André Kertész. Text by Pierre MacOrlan. Paris: Éditions d'Histoire et d'Art, Libraire Plon, 1934.

Nos amies les Bêtes par André Kertész. Text by Jaboune. Paris: Éditions d'Histoire et d'Art, Libraire Plon, 1936.

Les Cathédrals du Vin. Text by Pierre Hamp. Paris: Établissements Sainrapt et Brice, 1937.

Day of Paris. Text by and edited by George Davis. New York: J. J. Augustin, 1945. Layout by Alexey Brodovitch.

André Kertész, Photographer. Text by John Szarkowski. New York: Museum of Modern Art, 1964.

On Reading. New York: Grossman Publishers, 1971.

André Kertész: Sixty Years of Photography, 1912–1972. Edited by Nicolas Ducrot. New York: Grossman Publishers, 1972. Translation of 1927 Paul Dermée poem included.

J'aime Paris: Photographs Since the Twenties. Edited by Nicolas Ducrot. New York: Grossman Publishers (a division of Viking Press), 1974.

Washington Square. Introduction by Brendan Gill. New York: Grossman Publishers (a division of Viking Press), 1975.

André Kertész. Text by Carole Kismaric. New York: Aperture, 1976.

Distortions. Introduction by Hilton Kramer. New York: Alfred A. Knopf, 1976. Two hundred photographs.

Of New York. New York: Alfred A. Knopf, 1976.

André Kertész: Landscapes. Edited by Nicolas Ducrot. New York: Visual Books, 1979. Sixty-four illustrations.

André Kertész: Americana. Edited by Nicolas Ducrot. New York: Visual Books, 1979. Sixty-four illustrations.

André Kertész: Birds. Edited by Nicolas Ducrot. New York: Visual Books, 1979. Sixty-four illustrations.

André Kertész: Portraits. Edited by Nicolas Ducrot. New York: Visual Books, 1979. Sixty-four illustrations.

from my window. New York: New York Graphic Society/Little Brown, 1981. Fifty-three four-color reproductions.

On S'Amuse. 1981. One hundred photographs in pairs for unrealized book.

Hungarian Memories. Introduction by Hilton Kramer. New York: New York Graphic Society/Little Brown, 1982. One hundred and thirty-seven black-and-white and twenty-one four-color reproductions.

Kertész on Kertész: A Self Portrait. Text from interviews conducted by Peter Adam. Edited by Anne Hoy. New York: Abbeville Press, Inc, 1985.

Books and articles about André Kertész

André Kertész. Text by Keith Davis. Chicago: Edwynn Houk Gallery, 1985.

André Kertész. Robert Delpire, ed. Paris: Pantheon Photo Library, 1985.

André Kertész: A Lifetime of Perception. New York: Harry N. Abrams, Inc., 1982.

André Kertész: Of Paris and New York. Essays by Sandra Phillips, David Travis, and Weston Naef. New York: Metropolitan Museum of Art, 1985.

André Kertész: The Manchester Collection. 1984

Pierre Bost, "La Salon des indépendants de la photographie." *La revue hebdomadaire et son supplement illustré*, No. 24 (1928).

Brassaï, "My Friend André Kertész." *Camera*, No. 4 (1963).

"Caricatures and Distortions." *Encylcopedia of Photography*, Greistan Press.

Bruce Downes, "André Kertész: Day of Paris." *Popular Photography*, No. 6 (1945).

Owen Edwards, "Zen and the Art of Photography." *The Village Voice* (5 April 1976).

Ainslie Ellis, "A Triumph for the Innocent Eye: The Work of André Kertész." *British Journal of Photography* (20 October 1972).

Anna Fárová, *André Kertész—Photographic Series*. New York: Grossman Publishers (1966).

Colin Ford, *André Kertész*. London: 1979.

Jean Gallotti, "La Photographie, est-elle un art?" *L'Art Vivant*, Paris (1 March 1929).

Bertrand Guegan, "Kertész et son miroir." *Arts et Métiers Graphiques*. Paris No. 37 (1945).

Lois Greenfield, "Kertész Discovered at 70." *Changes* (April 1975).

William Hoseman, "André Kertész." *Infinity*, No. 4 (1959).

Anne Hoy, ed. *Kertész on Kertész: A Self Portrait*. New York: Abbeville Press, Inc., 1985.

Bill Jay, "André Kertész: A Meeting of Friends." *Creative Camera* (August 1969).

Carole Kismaric, "The Master of the Moment." *Sunday Times Magazine*, London (13 January 1980).

Hilton Kramer, "Kertész Conveys Poetic Significance of Details." *The New York Times* (January 17, 1973).

——. "Two Masters of Photography." *The New York Times* (March 27, 1976).

Zay Laslo, "Az Ember A Kep Es A Muveszet." *Foto*, No. 6 (1971).

Pierre MacOrlan, "La photographie et le fantastique social." *Les Annales*, Paris (March 1927).

Janet Malcolm, "On and Off the Avenue." *The New Yorker* (May 1, 1971).

Carlo Rim, "Défense et illustration de la photographie." *Vu*, Paris (April 20, 1932).

——. "Grandeur et servitude du reporter photographie." *Marianne*, Paris (February 21, 1934).

Leo Rubenfein, "André Kertész: French Cultural Services." *Artforum* (Summer, 1976).

John Szarkowski, "André Kertész, Photographer." Museum of Modern Art, New York City. Recension of catalogue and exhibition: London *Times* (March 25, 1965).

Margaret R. Weiss, "André Kertész, Photographer." *Saturday Review* (December 20, 1964).

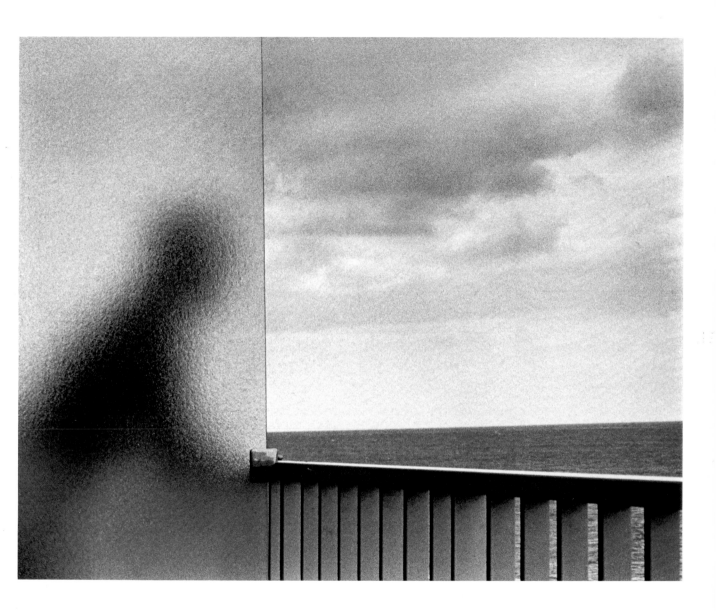

APERTURE MASTERS OF PHOTOGRAPHY

PAUL STRAND

Number 1
Essay by Mark Haworth-Booth

HENRI CARTIER-BRESSON

Number 2
Essay by Henri Cartier-Bresson

MANUEL ALVAREZ BRAVO

Number 3
Essay by A. D. Coleman

ROGER FENTON

Number 4
Essay by Richard Pare

DOROTHEA LANGE

Number 5
Essay by Christopher Cox

ALFRED STIEGLITZ

Number 6
Essay by Dorothy Norman

EDWARD WESTON

Number 7
Essay by R. H. Cravens

MAN RAY

Number 8
Essay by Jed Perl

BERENICE ABBOTT

Number 9
Essay by Julia Van Haaften

WALKER EVANS

Number 10
Essay by Lloyd Fonvielle

ANDRÉ KERTÉSZ

Number 11
Essay by Carole Kismaric

The Aperture Masters of Photography series provides a comprehensive library of photographers who have shaped the medium in important ways. Each volume presents a selection of the photographer's greastest images. 96 pages, 8 x 8, 42 black-and-white photographs; hardcover, $22.95; paper, $14.95.

The series is available at fine bookstores. If unavailable from your bookseller, contact Aperture, Box M, 20 East 23rd Street, New York, NY, 10010. Tel. (212) 505-5555; FAX (212) 979-7759. A complete catalog of Aperture books is available on request.